PAINTING
WITH ACRYLICS

Painting with Acrylics

Original title of the book in Spanish: *Guía Para Principiantes: Pintura al Acrílico*
© 2006 Parramón Ediciones, S.A.—World Rights
Published by Parramón Ediciones, S.A., Barcelona, Spain
Text: Gabriel Martín Roig
Projects: Gabriel Martín, Mercedes Gaspar, Esther Olivé de Puig
Photography: Estudi Nos & Soto

English Translation: Michael Brunelle and Beatríz Cortabarria

All inquiries should be addressed to:
Barron's Educational Series, Inc.
250 Wireless Blvd.
Hauppauge, NY 11788
www.barronseduc.com

ISBN-13: 978-0-7641-6048-6
ISBN-10: 0-7641-6048-6

Library of Congress Catalog Control No.: 2007922521

Acknowledgments
Our thanks to the Escola d'Arts i Oficis of the Diputación de Barcelona, to Enric Cots, Josep Asunción and Gemma Guasch, as well as the students Antonia Cauché, Enrique Clapers, Juan Gutiérrez, Rosa María Martín, Pilar Millán, Joan Pinós and Inés Rabanal, for their support and collaboration in the execution of the exercises from the section "Work by Students."

Printed in Spain
9 8 7 6 5 4 3 2 1

CONTENTS

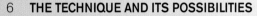

Introduction
A Contemporary APPROACH

Acrylic painting is the newest pictorial method. Its origin dates back to the 1920s, when a group of Mexican painters (José Clemente Orozco, David Alfaro Siqueiros, and Diego Rivera) wished to paint large murals with paint that was very resistant to inclement weather. They needed a medium that dried very fast and that was not easily altered. What they were looking for was already being used in the industry: plastic resins. All they had to do was adapt synthetic resin as a medium for binding pigments.

Toward the middle of the 1930s, Alfaro Siqueiros moved to New York, where he continued to experiment with this new synthetic resin that is now known as acrylic. He became acquainted with members of the avant-garde movement in the United States, who learned from him how to use acrylic paints. This is how many painters in the United States began to realize that the possibilities of the new medium surpassed the traditional media such as oils and watercolors.

As a result of the growing interest in this new pictorial medium, paint manufacturers saw a business opportunity and began to manufacture colors to supply to artists. By the end of the 1950s, it was possible to find materials for acrylic painting in the United States.

In Europe, acrylic painting started later. During the 1950s, some paint manufacturers from the United States gave their product to well-known artists so they could try the new material, which they did for several years. The research, experimentation, and popularity of this medium developed very slowly, and until the mid-1960s it was not possible to find acrylics in European art stores. In recent decades, this medium has expanded considerably so that it enjoys the same acceptance today as the other more traditional pictorial methods.

THE TECHNIQUE AND

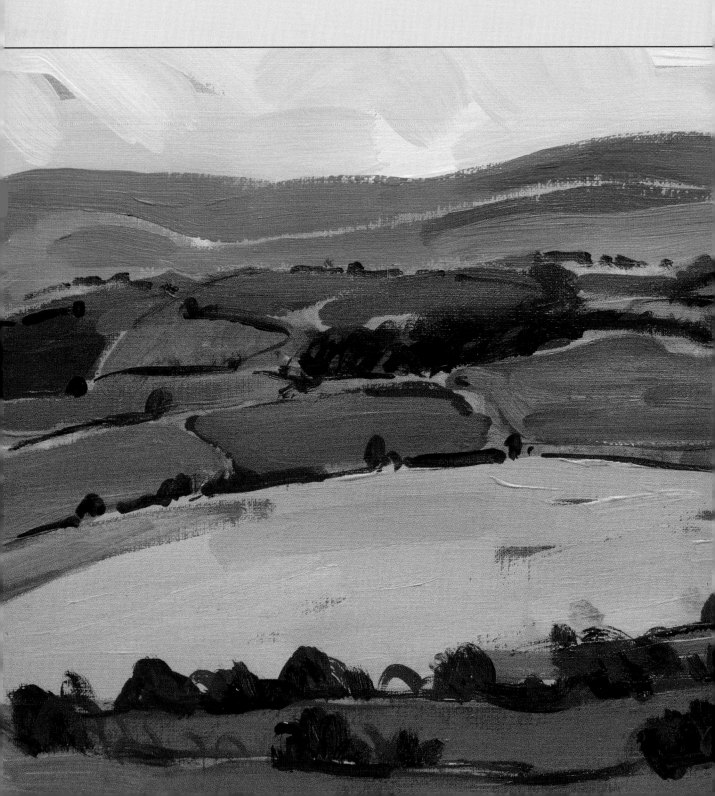

ITS POSSIBILITIES
THE TECHNIQUE AND ITS POSSIBILITIES

Acrylic paints can produce similar, if not better, results than the more traditional techniques. They combine the main characteristics of other media into one by achieving the transparency of watercolors, the opacity of gouache, and the density and pastiness of oils. This chameleon property is enhanced by the fact that the work needs little planning, since acrylic paints can be worked directly without much worry and can be applied on almost any absorbent support. When the layer of paint dries, it becomes a permanent and water-resistant film, which will not change its color or crack with the passage of time. The advantages of acrylic paints make this an interesting medium for the beginner to experiment with.

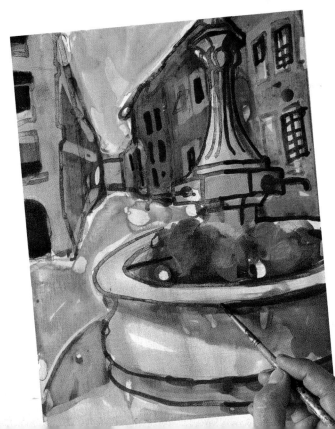

The acrylic paint that accumulates on a palette turns into plastic flakes when it dries.

Presentation and CHARACTERISTICS *of the Medium*

Acrylic paint adapts to a great variety of surfaces, and it is easier to use than any other traditional medium during the first stages. Its resinous component provides consistency, viscosity, and texture stability to the paint after it dries.

Great Versatility

The most important aspect of the acrylic medium is its versatility. It can be used in washes and in very thin glazes, or with a pasty and very thick consistency, providing richly textured effects.

A Paint that Turns into Plastic

Acrylic paints are agglutinated pigments in a polyvinyl emulsion that dry as a result of the evaporation of the water they contain forming an elastic, transparent, and very resistant film, with a consistency similar to plastic. After it dries, acrylic paint becomes more flexible.

Acrylic paint can easily mimic the effects produced by other mediums like oils, watercolors, and gouache.

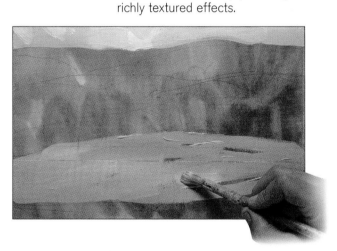

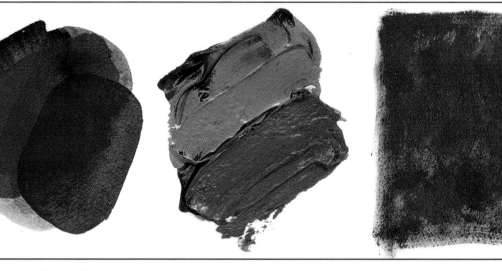

Acrylic paints can be used in many different consistencies. We can create glazes by adding plenty of water or an acrylic medium to the paint.

Opaque textures can have a distinct relief, if we work with the undiluted paint. Impastos can be applied with a brush or with a spatula.

The effects of sfumatto are achieved with very little dilution of the color using dry and undiluted brushstrokes.

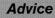

Fast Drying: Advantage or Disadvantage

Acrylics dry very fast, which makes it possible to layer colors without causing them to mix with each other. What appears to be an advantage can also be a disadvantage because there is less time to work with the paint on the support, forcing the amateur artist to work fast, which can make him or her feel uneasy.

Avoiding Oil Paint

Acrylic paints can be applied to any surface with the exception of oil paint bases. Therefore, it is not recommended to use acrylics on a surface previously painted with oils, mineral spirits, varnish, or synthetic enamel because the paint can crack or flake off after a few months.

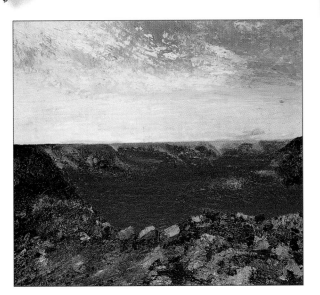

Acrylic paints do not turn yellow or harden with time. It is not necessary to treat the surface of the painting with varnish. Painted by Juan Gutiérrez.

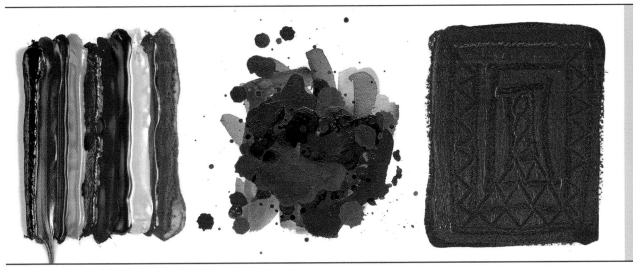

In addition to the traditional transparent, opaque, and dry brush painting approaches, acrylics can be squeezed or applied in ribbons, which turn into plastic bands after they dry.

It is not necessary to be very neat when applying acrylics since they can also be sprayed or splashed onto the support when the desired result is more expressive and casual.

When the surface of a painting is covered with a layer of opaque paint, it can be scraped to create a sgraffito look that creates linear effects.

AN ENDLESS SOURCE OF EFFECTS

It is important to dilute the paint with plenty of water to apply washes.

Acrylic WASHES

Painting with Acrylic WASHES

Acrylics can be used diluted, layering various washes of transparent colors. With respect to watercolors, acrylics are no longer soluble when the paint dries, which allows for the layering of washes without colors changing or mixing.

Acrylic washes mimic the effects of watercolors.

Diluting with Quantities of Water

When we dilute acrylic paints in a large amount of water or medium, as with traditional watercolors and oil paints, we can create delicate washes and glazes through which the white surface of the paper or canvas comes through, an effect that enhances the luminosity of the colors.

Working Fast

Washes produce some of the most attractive effects that can be created with acrylics. Their drying time varies depending on the support's level of absorption, the color used, the amount of water, and the room temperature. A thin acrylic wash dries very fast; that is why any corrections should be made quickly.

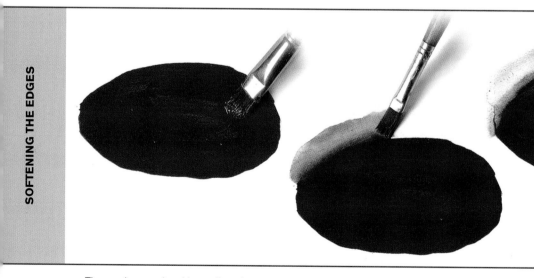

The washes made with acrylic paints dry very quickly, and unless the edges of the painted areas are softened with a wet brush, they can look very hard.

To prevent the edges from looking too defined, the work is executed with two brushes, one with paint and the other with water. The edges are softened by brushing them with a wet brush.

When the edges are dampened with water, the paint flows creating a gradation effect, blending and softening the hard line of the original contour.

If the support is dampened with water beforehand, when the paint is applied, it flows and expands to diffuse the edges.

Advice

One of the difficulties with washes is controlling the paint so it can be distributed evenly. This can be solved by adding a fluidity enhancer or a small amount of matte or bright medium to the wash.

Unchangeable and Permanent Washes

Acrylic paint washes dry as soon as the water evaporates. Once this occurs, no other chemical action takes place; the paint becomes insoluble and permanent. This means that the artist can add more washes to surfaces that are completely sealed, with the assurance that the new colors will not mix with the previous ones.

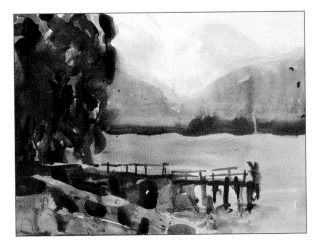

When painted on damp paper, the colors flow and mix with each other. Once the paint is dry, it is insoluble, unlike watercolor.

Painting on Wet

With acrylic paints, it is possible to paint wet on wet. First, the surface of the support is dampened and then the paint is spread and allowed to flow freely. With each brushstroke, the color is applied in a casual and spontaneous manner creating very airy and atmospheric effects.

The drying of the wash can be interrupted to achieve interesting graphic effects. First, the object is painted with paint and plenty of water.

When acrylic washes are drying, the edges are the first ones to dry. To take advantage of this characteristic, we wait a few minutes and then wash the surface with a wet sponge.

The water has removed the sections that were not dry, right in the center of the areas of color, leaving some parts unpainted. The result is very appealing graphically.

ALTERING A DRIED WASH

OPAQUE
Techniques

The artists who work with acrylic paints use them often in their dense and opaque form. The paint works very well for this type of approach, and since mistakes can be corrected by painting over, it is the best medium for learning to paint.

To make acrylic paint more opaque, we mix the color with a small amount of gesso.

Maximum Opacity

To achieve maximum opacity with acrylic paints, a charge can be added to them, in other words, we add small amounts of gesso, modeling paste, or pumice to the paint. To produce smooth areas of deep color with few or no brushstroke traces, we apply several superimposed layers of fairly thick paint.

Consistency of the Paint

Undiluted acrylic paint has a thick consistency. For color techniques with body, acrylics can be used the same way as gouache; even though acrylics do not have the same opacity as gouache, they mimic the effect convincingly.

Opacity and Transparency of Colors

Some acrylic colors are opaque by nature: for example, cadmium red and yellow ochre. Others, like quinachridone red or the range of yellows, are more transparent due to a lower amount of pigment content.

Opaque colors can be used over blue washes, which is the best color for painting shadows. Blue is applied somewhat diluted only for the shaded areas.

When the blue wash has dried, the medium tones are added. The paint is a little thicker. The areas of color are not very precise and blend together.

They are covered with orange, even the areas where the light hits directly. This way we create a strong contrast of complementary colors between the blue of the shadow and the orange of the light.

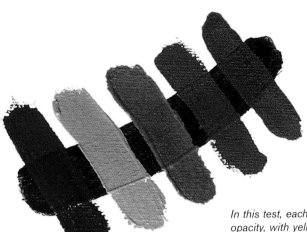

Advice

Some manufacturers make a variation of their paints in a more fluid consistency called Flow Formula. It adheres to the brush and is especially suitable for covering large areas with flat and opaque color.

In this test, each color shows a different degree of opacity, with yellow being the most transparent and green the most opaque.

Expressive Brushstrokes

To create an expressive feeling, the paint must be sufficiently dense to hold the brush marks. This way, the direction of the stroke helps define the object, in addition to creating a surface that is attractive and has character. It is a good idea to avoid heavy impastos because the shiny quality of acrylic paints can create an overall plastic feeling.

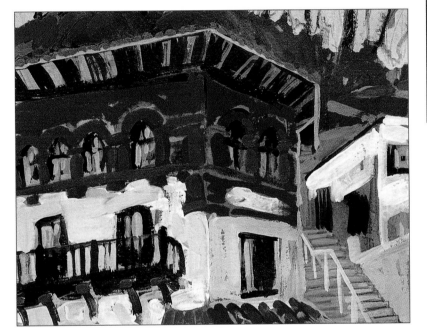

Thick paint is ideal for applying directional and expressive brushstrokes that help define every plane of the model's surface.

It is not necessary to cover an area completely with a layer of color applied evenly. If we change the pressure and the direction of the palette knife the color of the painted background can be partially exposed.

A very painterly and textured effect can be created by applying the paint on the support exclusively with the rounded tip of the spatula. The paint becomes thick, and the colors are mixed in a very controlled manner.

The most linear impastos are created by applying the paint with the edge of the blade. It produces a more dynamic surface, almost kinetic.

THICK PAINT APPLIED WITH A SPATULA

13

COLOR
in Acrylic Paints

Acrylic paints provide a range of pure and bright colors. Working with them in paintings that have a marked colorist feeling is a great advantage since one can be sure that they will not lose their luminosity after they dry.

Painting with Luminous Colors

With a colorist approach, shading is not used to represent the volumes of the objects; rather they are interpreted by painting the areas of light with bright colors. Shadows are not represented with tonal gradations, but with brushstrokes of saturated color that contrast with those of the illuminated areas.

Applying Even and Saturated Color

The different areas are created with saturated colors, mixed lightly, more or less evenly. The forms are created through contrast created between the different colors. Every color is applied inside its own space, keeping in mind that each one of them is going to have an effect on the adjacent color.

In a colorist approach each area is created with deep colors. The paint must be dense and pasty.

Colors should not be darkened or lightened with black and white if the desired result is bright and saturated. The first one muddies them too much, while the second gives them a pastel-like look and diminishes their vitality.

It is best to use always light or dark colors from the same range, creating tones that are livelier and more pure.

The effect can be compared in a single color. The gradation created with colors from the same range produces cleaner values than the tones modified with black and white.

Still life created by contrasting complementary colors: yellow, orange, and red for the illuminated areas and violet, blue, and green for the shaded ones.

In colorist paintings, the work is carried out with saturated colors, that is, with colors that are intense and light and that contrast with each other.

Complementary Colors

Artists tend to play complementary colors against each other in their work because this way the painting becomes livelier and acquires chromatic intensity. However, it is normal for the contrasts to look attenuated, toned down when they get mixed with other adjacent colors. Pure contrast between complementary colors can sometimes look too strong.

Colors become darker when they dry. Compare these samples: on the right of each sample, the color was recently painted; on the left, the color is already dry.

The Colors Darken

When acrylic paints are wet, they look saturated, bright, and light. When the paint dries, the agglutinate becomes transparent,

and the colors darken slightly and increase in intensity. This is why the color should be applied somewhat lighter than the desired final result.

Painting light colors over dark backgrounds can present a problem. A yellow color that may appear opaque turns transparent when it dries.

To avoid the problem, a layer of white is applied over the particular area.

When the white paint is dry, the area is covered with yellow. Even when the yellow dries the color remains sharp and pure.

WHITE STROKES

15

COLOR

Backgrounds

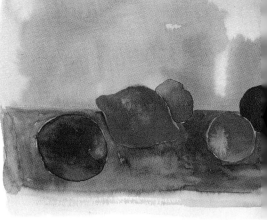

Working over COLOR BACKGROUNDS

A white background must be used when working with acrylics diluted with water.

When painting over color backgrounds, it is much better to work with values because this way it will be as easy to paint light colors as dark ones from the beginning. If this is the case, the artist must learn to choose the appropriate background color for each particular occasion.

White Support for Diluted Paints
Some artists prefer to have a white background, especially if they are using diluted paints because the light that comes through the paint gives the piece a luminous quality. Others find the white surface bothersome because it makes it difficult to judge the lightness and darkness relative to the first colors.

White Is Intimidating
A white background may make it difficult to choose the first colors that are to be applied on the canvas. Normally, there exists the risk of using a tonal range that is too bright because most colors look very dark against a white background. For this reason, many artists prefer to cover the canvas with a solid color before they begin painting.

The selection of the color for the background is a determining factor. Here, the yellow area surrounded by white appears darker than when it is surrounded by a medium blue. This effect is even more noticeable if we compare them with the one framed with dark blue.

It is possible to use opaque colors over a medium background satisfactorily. First, the area is covered with brown paint.

The light colors stand out sharply against this background. However, the medium red does not stand out enough because it is similar to the background color.

We can draw certain conclusions when we apply dark black. Over medium intensity backgrounds, the work should be carried out with light colors and intense darks.

Neutral colors like blues, grays, and browns work best for backgrounds.

Advice

Some colors are not recommended for backgrounds; among them are yellow and bright violet.

The white of the paper often inhibits the artist; that is the reason the support is covered with paint.

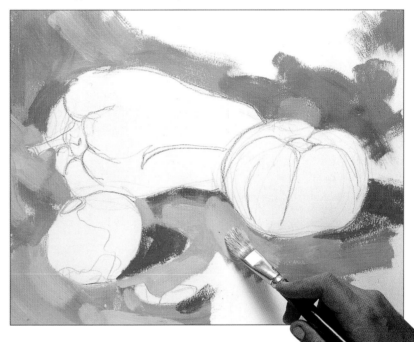

Painting the Support

Painting the background is easy: diluted acrylic is applied over the entire surface, which dries in a matter of minutes. Most commonly a neutral color, such as gray, grayish blue, or ochre, is chosen. Some artists always use the same color; others choose a different one for each painting.

Different shapes of green painted over a saturated red background provide a loud effect due to the contrasting complementary colors.

Now the color of the background is light blue. The colors of the shapes look warm. This way, the background becomes less relevant and it appears to recede in respect to the forms.

Neutral color backgrounds (like gray, ochre, and the browns) tend to harmonize without creating excessive contrast against the colors of the superimposed shapes.

DIFFERENT BACKGROUND COLOR TESTS

Dragging
the COLOR

Dragging
the COLOR

Using a wide spatula, we can easily blend the colors. If in addition we move the hand back and forth, we can create this interesting effect.

This consists of spreading or scraping the paint over the entire surface using a flat tool, for example a rasp, a spatula, or the edge of a ruler. With the dragging technique, the layers of color are extensive and flat and cover the surface of the painting easily.

Synthesizing

This method is similar to painting with a spatula, even though the layers of paint are more extensive and less precise and controlled. It is used to paint with large, synthetic strokes that depart from any controlled treatment because detail has no place in the dragging technique.

Blending Colors

The scraper blends colors together by layering them in bands or strips, maintaining the purity of the color. To cover the entire surface with a single stroke, a large scraper is used with a generous amount of the different colors placed at the edge of the paper. The colors are spread with a single stroke so they blend together forming gradations. If the artist does not want the colors to blend, a single color is placed on the edge and applied evenly over the entire background.

When painting with a spatula, spread the color on the surface by dragging. This approach does not allow for details.

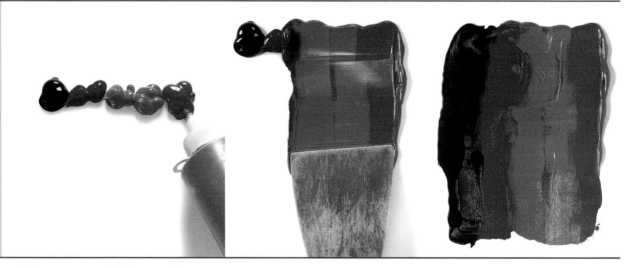

We can prepare a background with bands of color by dragging as follows. First, line up the paint on the upper part of the paper.

Using a wide spatula drag the paint to cover the entire paper creating a smooth surface.

This method turns the initial paint into clearly defined bands of color where the colors are not excessively mixed.

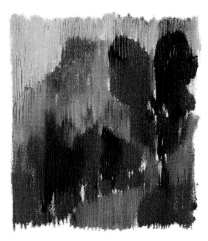

By using a toothed plastic or rubber scraper, we can give the surface of the painting a treatment that mimics the effect of rain in a landscape.

Transparency Effects

If we want to work with transparencies, we can spread the color in very thin layers in such a way that the white of the support provides brilliancy and depth. Another way of working with this method is by using a slightly tinted acrylic medium over another color to create a glaze effect that gives depth to the color.

Impastos and Toothed Scrapers

If we are looking for the opposite effect, we can give the paint more body by adding a small amount of gesso or other thickening medium. Toothed scrapers for plaster can be used to create grooved effects. They can also be achieved with an improvised cutout of hard cardboard or plastic.

Before applying the dragging effects with the toothed scraper, it is a good idea to test them on a piece of scrap material.

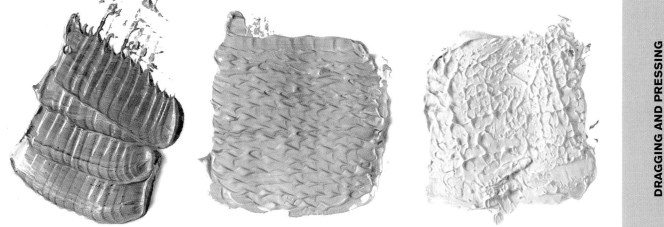

When working with a thick layer of acrylic paint, different striated texture effects can be created by dragging the paint with a toothed knife or comb.

If we press the layer of paint with the blade of the flat spatula and then lift it, the paint is raised, forming small pointy peaks.

A scaly surface can be created by applying a little pressure at regular intervals with the tip of the spatula, marking the layer of uniform color.

DRAGGING AND PRESSING WITH THE SPATULA

19

TRANSPARENT *Techniques* *with* ACRYLICS

Acrylic paints allow the artist to play with the transparency of the colors by creating thin glazes that provide a subtle and atmospheric finish to the work. There are two basic ways of increasing the transparency of a color: adding water to the paint or mixing it with a transparent acrylic medium.

Glazes

Applying a glaze consists of covering the color with a thin layer, that is to say, saturating the entire surface of the painting with a layer of translucent paint. This is achieved by diluting the color and applying it on the support as if it were a wash. Acrylics dry so fast that several glazes can be applied within a short period of time.

Additive Mediums

Nowadays artists can find a variety of substances in the market to help them make the paint more fluid and transparent. Some of these mediums improve the quality of the glaze or the transparency of the color or enhance their brightness or the crackled effect when they dry.

Glazes are applied in layers. After one layer dries the next one is added.

Glazes are used not only for painting but also for changing the tone of the colors. Let us look at some examples of various areas of color.

The strokes of color are covered with a yellow wash. When wet the wash looks very dense, but it looks more transparent after it dries.

Now the wash has dried and it appears a little more transparent. The colors underneath are still visible, although they appear modified by the yellow color.

A glaze is a layer of translucent color that covers another color altering its tone.

Advice

Some colors are more transparent than others, and sometimes it is necessary to dilute the tone a lot to achieve the desired transparency.

Some transparent or drying-retardant mediums give consistency to glazes and prevent the excessive dispersion produced by the water.

Mediums to Increase Fluidity and Transparency

Instead of making a transparency by diluting the paint in a large amount of water, it is better to use a medium to increase the fluidity and the transparency so the paint does not lose its properties and stability. These mediums create very thin and transparent layers of color without separating the color. They are especially useful for glazes and transparencies.

Delaying the Drying Process

Normally, the glaze is applied over the painted surface after the latter has dried. This way, the paint's drying time is lengthened increasing the working time, especially with wet-on-wet techniques.

In glazes the mixing of colors occurs in the eye. This means that a new color is created when two different colors are superimposed.

Acrylic transparencies are not in conflict with texture; quite the opposite, they can work well if the paint is applied with a thickening gel.

When we mix the color with abundant gel, each brushstroke makes an imprint on the support. This way we can combine the transparency with gestural strokes.

Let us see an example on a painting. Upon drying, the gel becomes transparent and only the color glaze remains, which forms interesting textures that add dynamism to the surface of the painting.

TRANSPARENCIES WITH TEXTURE

TRANSPARENCIES *with* ACRYLIC MEDIUMS

The different mediums that are used with acrylic paints are a good solution for improving the quality of the transparency effects on the painting. A small amount of paint mixed with transparent or thickening gels, instead of water, will make it possible to apply more uniform and consistent glazes. Let us analyze some application methods.

A textured glaze is completely impossible to achieve with any other pictorial approach but acrylics. Thick gel with a small amount of paint is more than enough to apply a semitransparent stroke that will leave an imprint.

It is possible to create transparencies and textures with acrylic paints because this medium is perfectly suitable for textures and to model different forms with the help of a spatula. Here, we can see several layers of gel mixed with different colors.

Let us look at a different type of transparency that can be applied to the study of a conventional landscape after the paint has dried completely.

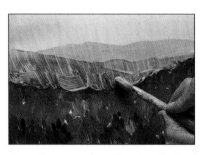

A small amount of acrylic paint mixed with thickening gel provides a color effect that mimics stained glass. This is a very useful approach to represent the effect of rain on the landscape because the brushstroke marks remain after the paint has dried.

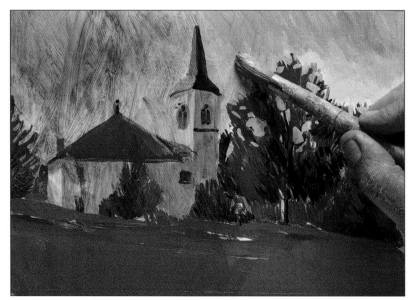

Glazes with mediums are also very suitable if the goal is to change the chromatic dominance of a painting or to create the feeling of aging. This landscape study is a good example.

WASHES *with* PAINT

This technique consists of applying the paint as a wash on a support that is not very absorbent such as a piece of primed fabric or wood, never on porous paper. The lack of absorbency makes the paint form puddles, which after drying create slightly diffused areas of color, resembling a glaze.

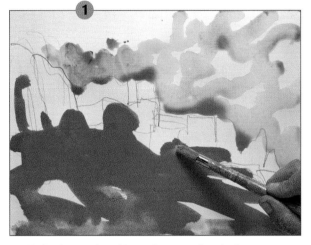

1. We begin to paint with washes covering the largest areas of the painting, the sky and the mountains, using paint very diluted with water. We leave a few areas of the sky unpainted to represent the clouds.

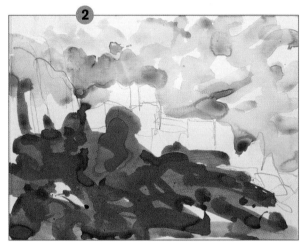

2. The edges of areas of acrylic color are the first ones to dry leaving puddles in the center, which is the last part to dry. When the previous layers have dried new layers of washes are applied: very transparent violet for the sky and green for the mountains.

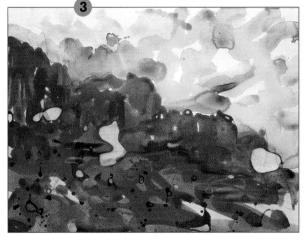

3. Because we know how acrylic paints dry, we can wash the areas that are still wet with a wet brush and a sponge. The result is circular voids in the shape of the puddles.

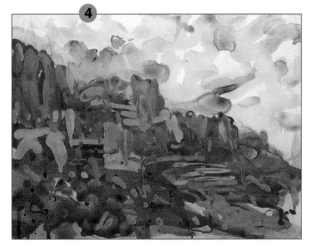

4. When we apply several colors, the composition is built up with many layers making the study look very detailed or providing the desired finish. If we tilt the support slightly, we will make the paint from the puddles run.

Rollers and sponges are especially useful to paint large surfaces very quickly.

ALTERNATIVE *Methods of* *Painting with* ACRYLICS

When we talk about alternative tools for painting, we refer to any implement for applying paint on the support or leaving a mark on it. Therefore, a resourceful artist may find many objects that replace the brush and that create new effects on the surface of the painting.

Sponges and Rollers
Sponges can be used to paint large areas of color very fast without leaving any marks. They can be used by themselves or with a roller, which provides even coverage of the surface and makes it possible to create glazes.

Wide or Household Brush
This is a flat brush with a wide tip that can cover large areas with a single brushstroke. Charged with a small amount of paint, it can create blends and gradations of great precision.

The main appeal of this brush is its wide, striated, and very gestural stroke.

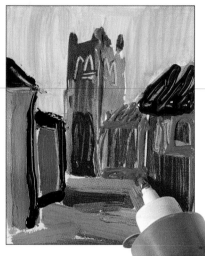

Paint applied directly from the tube is used in some paintings to highlight the linear effects in a very effective way.

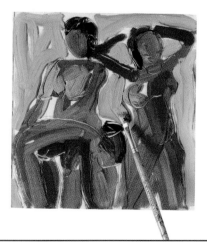

A monotype is created by making a painting on glass. To prevent the paint from drying too fast, retardant gel is added to each mixture.

A white sheet of paper is placed over the wet painting, pressing firmly with the hands. Then, the paper is removed carefully to check the results.

The results of the monotype are unpredictable and whimsical. They are characterized by textures and graphic effects of great originality.

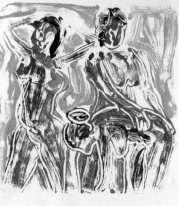

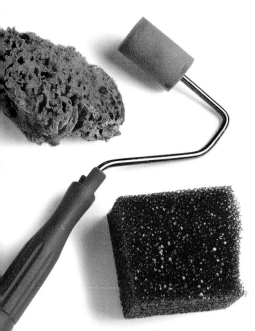
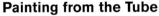

Advice

Paint can be applied directly from the tube, but the lines obtained this way are too thick. It is better to attach a special tip to the tube or to purchase containers of paint that already come with the dispensing tip.

Painting from the Tube

Paint that is dispensed directly from the tube is piped or applied through a funnel or tip. This method produces a distinct line that has some relief. It is important to control the amount of paint that is dispensed with precision and to maintain a constant flow.

Spattering

This method consists of submerging an old toothbrush in paint that is fairly diluted, holding the tooth-brush horizontally over the surface of the painting, and then rubbing the bristles with the tip of the thumb. The paint comes out fast as droplets that spray the surface of the paper.

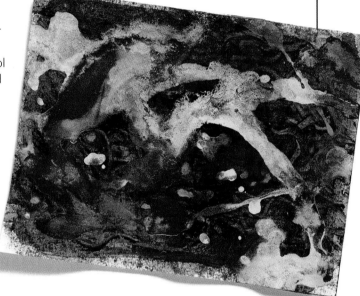

Spattering or spraying the paint over color backgrounds creates an interesting dynamic and expressive effect that is worth trying.

Spattering paint on a support can be used to enhance an abstract painting or to add interest to it. Templates are used to control spraying.

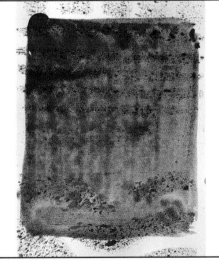

With the addition of each color, we limit the areas of the painting that we wish to spatter, avoiding spraying the others. This is why we use several templates.

When the spraying effects are finished, we use a medium round brush to draw a shape with thick and covering paint.

USING TEMPLATES FOR SPATTERING

Making reserves with adhesive tape produces color applications that have very sharp and clearly defined lines.

Reserves, SGRAFFITO and SANDING

Working with acrylics requires knowledge of many resources and the ability to use them at the opportune time because often many techniques go hand in hand very discretely in the same painting without affecting the overall style. Not only does acrylic painting incorporate effects using other mediums such as sgraffito and wax reserves, but other mediums for the acrylics are also developed based on the quick drying time and the elasticity of the material.

Reserves with Tape

One of the most common ways to create a composition with hard and straight edges is to use adhesive tape to make a reserve. The effect is very similar to the one created with templates.

Stenciling

This type of reserve made by cutting out a shape from a piece of cardboard, plastic, or stenciling waxed paper is placed on the support and paint is applied inside of it. It is very interesting in pieces where the areas of flat color acquire special relevance.

Very hard edges can be created with cardboard cutouts. This approach requires the use of thick, undiluted paint.

STENCILING

Sgraffito offers interesting line effects. First, we paint the support with light green. Then, we cover the color with heavy blue and red acrylic paint.

Using a metal spatula the fresh paint is removed by scratching the surface to draw a still life. The work is done quickly to prevent paint from drying out.

The sgraffito procedure breaks up the surface and exposes the green paint. This method is commonly used to suggest texture or to give the painting a very expressive appearance.

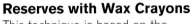

Sanding the surface with sandpaper creates interesting textures that produce an aging effect on the painting.

Advice

Wax crayons are difficult to erase once they are applied; this is why it is important to draw with precision or to plan carefully where to use them.

Reserves with Wax Crayons

This technique is based on the fact that water and oil do not mix. The idea is to cover the area intended for the reserve with a wax crayon and then to apply a layer of liquid acrylic over it. The underlayer of wax creates lumpy areas producing a spotted effect.

This color study combines acrylic washes with colors applied with wax crayons.

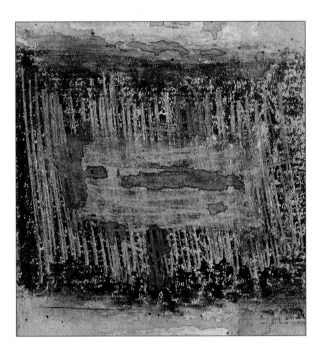

Absorption and Sanding

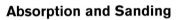

Absorption takes away paint from a specific area before it dries. Excess water or paint can be removed by pressing a piece of newspaper against that area. When the surface of the painting is dry, we can sand it with sandpaper to remove the paint. This procedure creates interesting textured effects if a colored background is used.

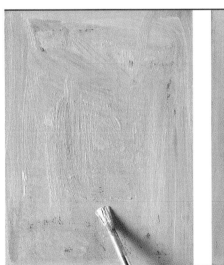

To get good results with this method, the support must be hard, like wood or masonite. We paint the background with bright colors and then cover it with a layer of light color.

When the paint has dried completely, we sand the surface vigorously with sandpaper scratching the painted surface.

When the layer of paint is scratched, the colors underneath are exposed creating an interesting textured effect with visible brushstroke marks.

SANDING WITH SANDPAPER

PAINTING *with* FLAT *and* OPAQUE *Brushstrokes*

The best way to construct a colorful painting is with strokes of flat and opaque paint because the sharp color contrasts help define the objects. Shading is not required because the different planes are formed through the contrast between bright and saturated colors.

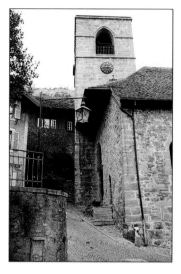

1. We make a pencil sketch over a blue background. The buildings and roofs are painted with thick colors that have good covering power by applying very flat brushstrokes without shading effects.

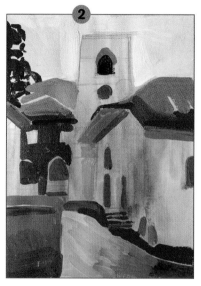

2. The brightest areas are painted with orange and reddish colors, while the shaded ones are treated with blue.

3. As the colors fill out each area, the shapes begin to emerge as a result of the contrast. If any of the colors needs to be lightened or defined, we wait until the surface has dried before we paint over it.

4. It is important to leave the smallest details, like the drains from some of the roofs, the fence, or the lamppost in the foreground, until the end. They can be painted with an oil pastel stick after the acrylic paint has dried. This gives greater graphic variation to the scene.

DRY BRUSH

This method consists of dragging the paint across the desired surface. This is usually done with a bristle brush on a surface that is slightly textured. The result is a surface with intermittent color and a grainy appearance since the higher areas retain the new color while the lower ones show the background paint.

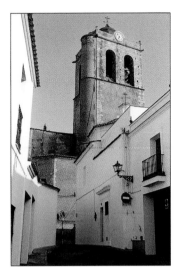

1. First, the shaded areas are covered with violet and the sky with blue. With the dry technique, the excess water in the brush is removed with a rag; the brush is then charged with a small amount of paint to avoid covering the white surface of the paper completely.

2. The paint is applied with a gentle rubbing motion. The bell tower is painted with yellow ochre and brown. The pavement of the street is painted with dark gray and violet, and the windows are also outlined with the same colors.

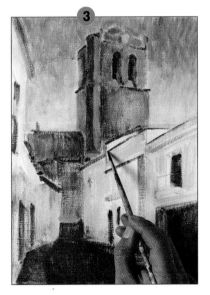

3. The upper part of the sky is darkened with a few more vigorous brushstrokes. The outlines of the roofs are painted with reddish sienna using a thin round brush.

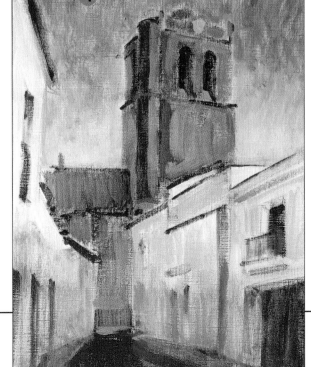

4. The shade and the details are painted with thinner round bristle brushes, superimposing new dry brushstrokes over the previous ones as if they were glazes applied over a color that is only partially covered.

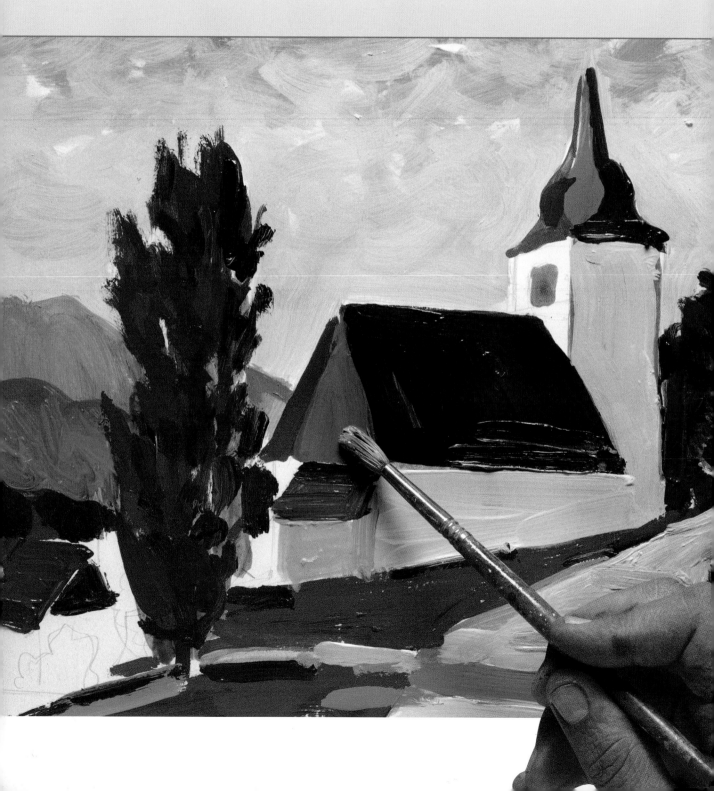

EXERCISES
PRACTICAL EXERCISES

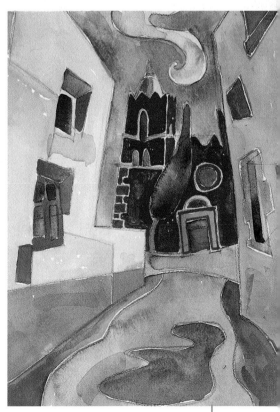

Acrylic paint is strong and flexible, it can be scratched, textured, dripped, sprayed, applied as a wash, or splashed onto the surface in a controlled fashion to form irregular and casual areas of color. The moment has arrived to practice all the techniques available to this medium and to expand on the possibilities inherent in this material with real exercises that integrate the most traditional techniques, adapted from other mediums like oils and watercolors, and other ways of working with colors that are typical of acrylic paint.

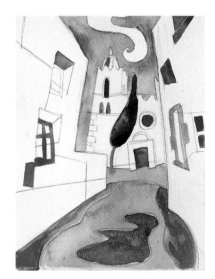

STILL LIFE *with* BRUSHSTROKES *and* GRADATIONS

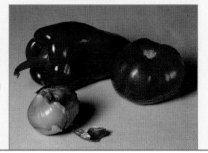

We begin this exercise section by using one of the simplest methods in existence for beginners: painting with brushstrokes and gradations. The support that we are going to use is very rudimentary, a piece of cardboard, which is a base that allows the paint to flow easily. Exercise executed by Gabriel Martín.

We draw the model with black pencil. The approach is very schematic. There is no point in spending time with the details because they will be covered by the paint.

Advice

The tomato is constructed by painting gradations for each area. This is done while the paint is dry because it is the only way to mix the colors to form gradations.

We paint the tomato, creating a different gradation for each section or lobe. These gradations range from green to orange, with ochre being the intermediate color.

32

3

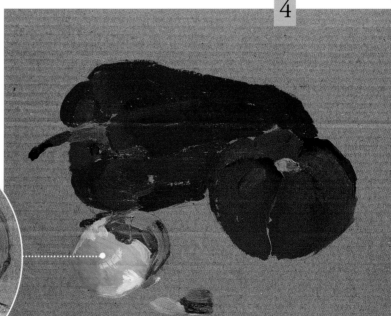

We work the areas of color for the pepper the same way as before. We begin with yellow and orange, which is gradated with ochre and brown. Then, red and carmine are introduced.

If we keep in mind that the light comes from the left, the oranges and the lighter reds should be placed on that side of the vegetable.

We continue with the onion, first by painting a gradation that ranges from medium violet tone (on the left) to a lighter violet (on the right). The skin is painted with ochre shaded with sienna and a small amount of white.

4

Over the gradations that make up the color and the shape of the onion, we paint a few lines with a small round brush to emphasize its texture.

Advice

Careful consideration is given to the application of color. To explain the volume properly it is important to plan ahead and to make sure that the brushstrokes are applied in the same direction as the surfaces of the objects.

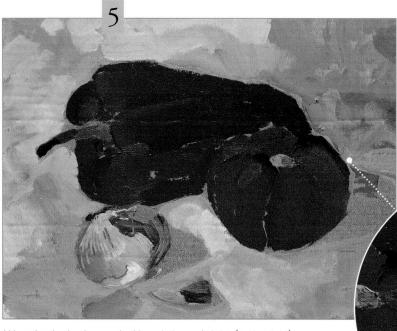

5

To paint the background, we can combine several different size brushes. We begin with medium violet, and as we progress, we lighten it, darken it, or give it a different chromatic hue.

We paint the background with variations of violet (to the right) and darker blue and turquoise colors (to the left). The color of the cardboard is not covered completely because leaving small spaces for the background to breath provides more appealing results.

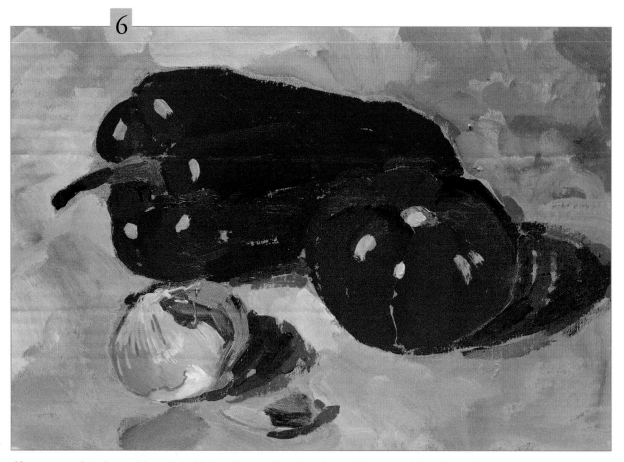

6

After we complete the exercise, we make sure that creating the volume of the vegetables with gradations produces satisfactory results. It is important to break up the monotony of the background by using the layered colors.

A COUPLE *of* CONSIDERATIONS

Now that the previous exercise is finished, it is time to reflect upon two interesting aspects that cannot be left out: the first one is the working method, the best way for mixing colors on the palette; the second one is a brief reflection on the cardboard that serves as support, a very useful material for professional artists, normally underestimated by amateurs.

+ brown + blue + dark green + red
+ emerald green + yellow + orange

Let's look at how the colors are mixed on the palette, taking the tomato as reference. The starting point is a large area of medium green color. We add different colors to modify this green until it evolves into reddish tones or a strong gray. The colors that take part in the progression of the mixtures are indicated above.

The other consideration is related to the support. Cardboard is a material, which due to its unassuming presence, is looked down upon by beginner artists. However, its abundance and good surface make it a much-appreciated material among professionals.

The color of the cardboard is another advantage. Its medium brown or gray color provides a good background for light color paints, and it is also very suitable for expressive representations like this one.

Cardboard is a good support for painting with thick and opaque colors and to leave small, unpainted areas through which the color of the background can be seen. It is not suited at all for working with washes.

This support does not require any priming at all. If we load the brush with paint, the bristles will glide smoothly over the surface, making the brush flow with ease.

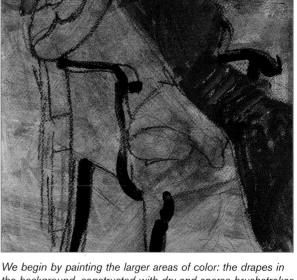

STILL LIFE *with Chair and Hat*

STILL LIFE
with Chair and Hat

We plan a still life that is more difficult than the previous one. This time we are going to work over a color background; therefore, we will be equally able to paint with light and dark colors. We will apply the paint heavily over the still life and more sparsely and dry over the background. Exercise executed by Mercedes Gaspar.

Advice

Many artists prefer to paint on color backgrounds to prevent colors from looking dark against a white surface. In this case, ultramarine blue works well as a neutral color.

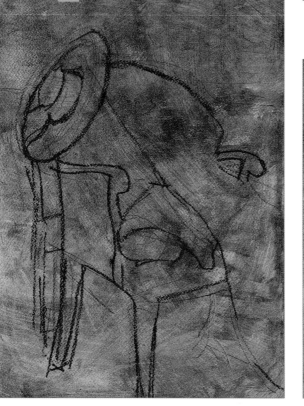

Over the blue base and using a couple of salmon and sienna pastel color sticks, we sketch the outline of the chair, on top of which have been placed the other objects that make up the still life.

We begin by painting the larger areas of color: the drapes in the background, constructed with dry and sparse brushstrokes of carmine, and the cloth painted as a single area of dense and even color.

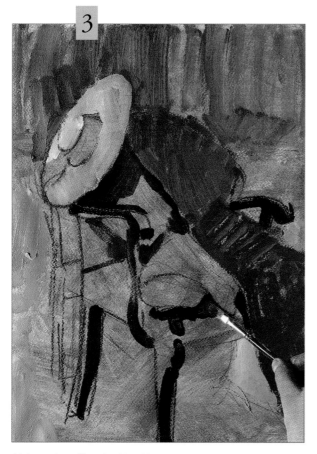

3

Using ochre diluted with white we paint the straw hat, leaving the area of the ribbon blue. Again, with dark brown mixed with green and using a smaller brush, we cover the more shaded areas of the chair's fabric.

Using green darkened with brown, and lighter green on the left, we finish the fabric of the chair. We paint the cloth with heavy white brushstrokes. The folds are created by leaving unpainted spaces through which the blue of the background can be seen.

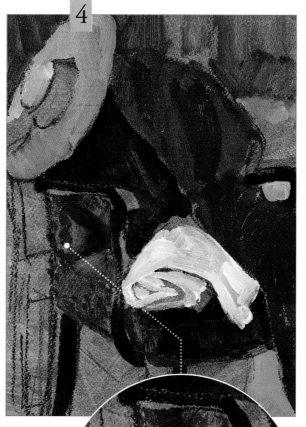

4

Using yellow-green and a few orange brushstrokes, we finish painting the most illuminated area of the chair's cover to the left. The short dot-like brushstrokes represent the light reflections.

The top part of the ribbon on the hat is painted with a small round brush loaded with gray and pink. The hanging part of the ribbon is painted black, without any gradations or shading.

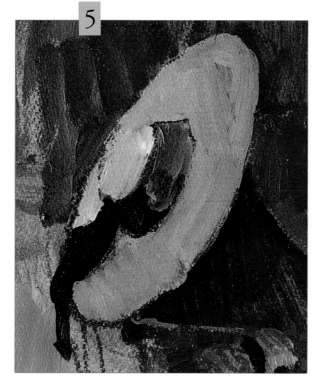

5

6

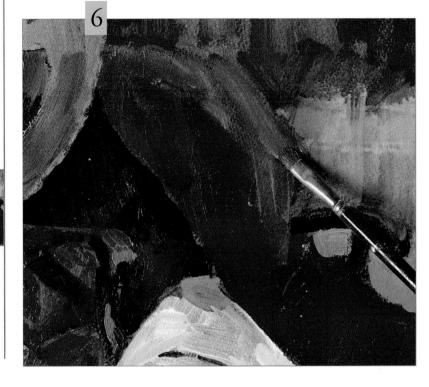

Advice

When the piece is painted on a color surface, it is a good idea not to cover it completely and to leave some areas unpainted so the underlying color can breathe and enhance the overall look.

The effect of volume on the cloth is created by layering new colors on top of the red. Gradations and contrasts between light and shadow are the main contributors to this effect.

7

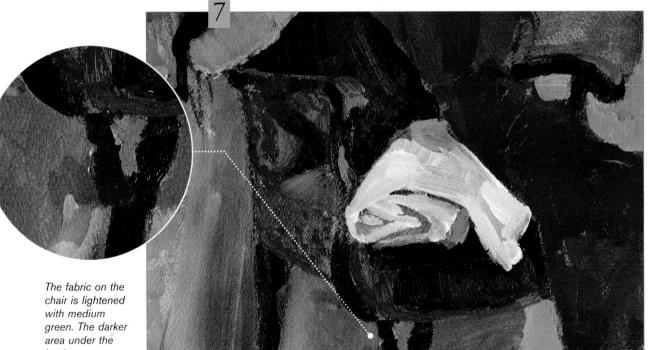

The fabric on the chair is lightened with medium green. The darker area under the hat becomes more restricted. In it, the transition between colors must form gradations. We apply brushstrokes of darker ochre to enrich the area below the seat.

Advice

The short strokes of light colors and contrasts are decisive to prevent some areas from getting mixed up with others.

When the main elements of the still life are completed, the background is painted with a larger brush. The colors used for this are ochre and gray-violet, both reduced with white. The underlying blue color should not be covered completely.

We go back to the cloth to apply contrasts between the folds and the shadows. The most illuminated areas are painted with red mixed with orange, while red mixed with carmine is used to highlight the shadows of the folds.

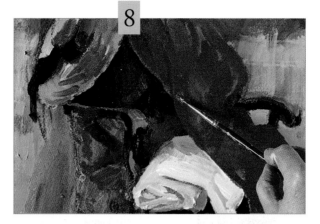

8

9

During the last phase, the paint is applied with a small round brush. The color additions are minimal, and they are only done to touch up shadows, to highlight texture, to emphasize a reflection, or to reinforce an outline that may have been erased in the process.

With a round brush loaded with pure white, we paint the areas of maximum light on the white cloth, leaving the shaded areas untouched, which should remain violet to define the folds.

Now we are going to compare the previous exercise executed by a professional artist with copies painted by art students. As we can see, the professional artist and the students have painted the same model. We can use this subject for drawing comparisons, to analyze the approach each student has chosen and the various ways they have used acrylics. Different techniques and interpretations provide different results that are worth analyzing. Learning from the accomplishments and good ideas of these students is very stimulating and can help us with our work.

Work by STUDENTS

This student has purposely chosen a close up to pay closer attention to the effects of the drapery. The student has chosen the technique of dry brush painting, which requires the paint to be thick, not diluted in water. This technique produces a granular and rippled effect, which helps represent the texture and tactile feeling of the drapery. To develop this technique properly, it is a good idea to use a support that has some texture on its surface. Executed by Pilar Milán.

Here is another very personal interpretation. Again, the setting is a determining factor for the intentions of the artist, whose main goal is to construct the model with large brushstrokes and applications with a spatula. Here, the paint is abundant, thick, and heavy, which helps create sgraffito effects. The result is creative, and to some degree it resembles an abstract piece. Executed by Rosa María Martín.

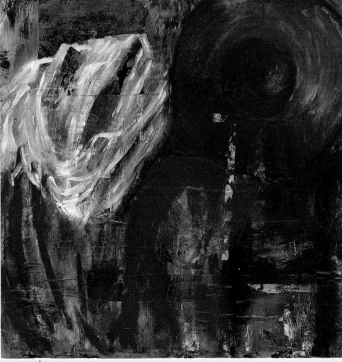

The appeal of this composition lies in the successful construction of the background, which has been painted with brushstrokes of different colors that give the piece a textured and abstract appearance. The hat has been painted on top with tight and dense gradations. The rest of the elements have been left sketchy, unfinished, painted with wide brushstrokes with circular motions that do not cover the background completely, giving the composition a feeling of movement. Executed by Inés Rabanal.

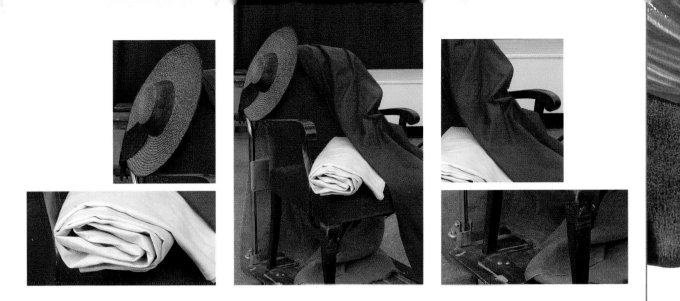

The introduction of other materials into the composition offers an interesting approach because they provide new graphic elements and textural effects that resemble those of the real model. This is why the student has glued pieces of fabric in the area where the red cloth is located. By painting over the cloth, the image appears coarse and textured. Another outstanding graphic element is the use of black lines of different thicknesses and intensities that highlight some of the outlines of the objects. Executed by Enrique Clapers.

The most illuminated areas look more vibrant against a dark background. The folds on the cloth appear more contrasted and modeled with soft gradations, which give a three-dimensional feeling to its surface. Again, the addition of newspaper cutouts provides graphic variety to the painting. The work combines some areas that have an unfinished look, painted with a few simple brushstrokes, with others that have a more naturalistic approach to color and shading. Executed by Joan Pinós.

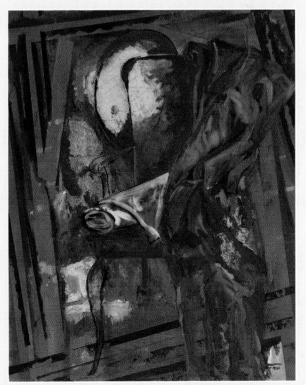

Cardboard is a type of support often used by art students because it is inexpensive and easy to store and carry. Its surface provides a dark background that is suitable for work with bright and saturated colors. Large areas of color can be created with a reduced number of colors and fluid paint. The areas with variations of light, like the hat or the pieces of cloth, can be resolved simply with two shades of the same color. Executed by Antonia Cauché.

Urban Scene with SATURATED COLORS

Urban Scene *with* SATURATED COLORS

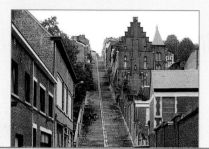

The contrast and vibrancy of the colors are the most important virtues of acrylic paints. Since this medium lends itself to the use of pure colors, we proceed to paint an urban setting with bright and saturated color contrasts. Therefore, the grays and browns for the shadows are eliminated to give way to color. The different light intensities and the position of the various planes of the scene are defined through the marked contrast between the colors. Exercise executed by Gabriel Martín.

To prevent the white support from ruining the chromatic effect, we paint it with a layer of blue. When the paint is dry, we draw the perspective lines for the steps.

Advice

After the overall structure has been drawn, we introduce the architectural details: windows, doors, cornices, chimneys . . .

In urban landscapes, the preliminary sketch is very important for solving any perspective issues that may arise. Each building should be approached as if it were a simple geometric shape.

Using a flat brush, we paint the steps forming a gradation between two complementary colors: yellow ochre for the top part and violet for its base. The mixture of both colors must be done quickly because acrylic paints dry fast.

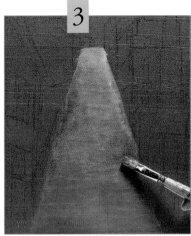

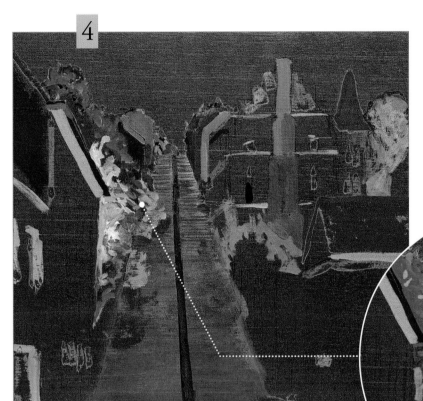

The vegetation is constructed by layering brushstrokes using a small round brush.

The roofs and the groupings of vegetation are painted with warm colors (yellow-orange, medium orange, magenta, and red). The contrast with the blue of the background gives these colors a very vibrant feeling.

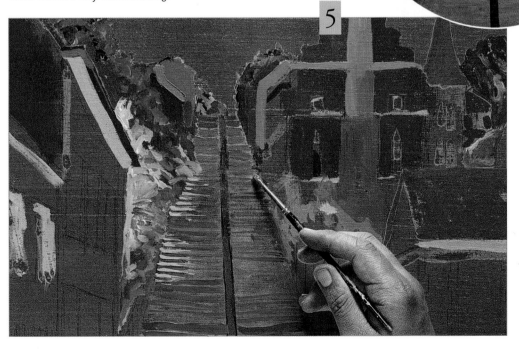

With the flat brush, we paint the color façades. The windows are painted with a round brush. We emphasize the gradation for the steps by painting vertical bands with more saturated colors.

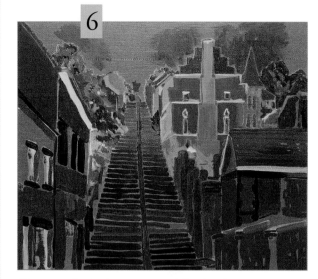

The areas of color become more defined and concrete as we progress. They help explain a plane, uneven ground, or the direction of the tiles on the roof. The blue of the background is exposed between the colors to provide some linear features.

With a thin, round brush we begin to paint the details: some lines and the texture on the walls of the nearby buildings. Each brushstroke must contrast with the color of the wall where it is applied.

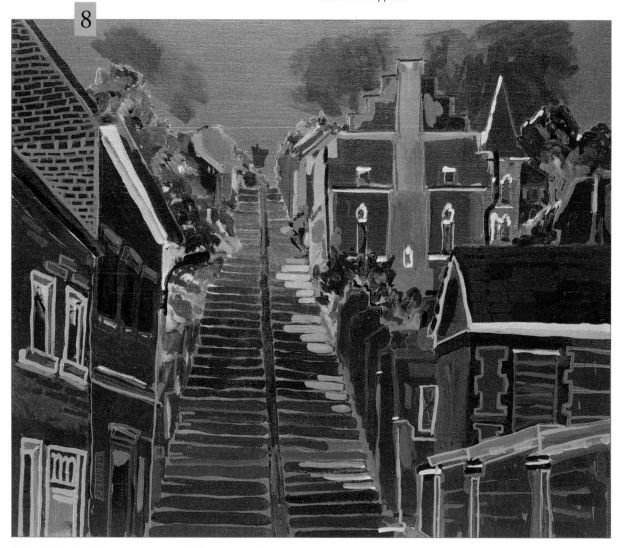

We add the details on the foreground. The shapes of the doors and windows in nearby buildings are painted with pinks, greens, and oranges. The colors are unreal, and their only purpose is to create vibrant contrasts.

AFFINITY *and* REJECTION *Between* COLOR *Contrasts*

Colors should not be combined at random when painting because their associations are not only a result of the artist's preferences, but also of other deeply psychological factors that have a universal response. In this sense, there are perceived contrasts, those that produce an affinity with the artist, and on the other hand, those that provoke a clear perceptive and psychological rejection. Let us see why this happens.

If we paint a color wheel with the three basic colors (cyan, yellow, and magenta), we will notice that these primary colors show the maximum degree of contrast with their complementaries: magenta with green, cyan with red, and violet with yellow.

Although the previous principle is accurate from the scientific point of view, it is not from the psychological point of view because we need to modify the previous contrasts for the viewer to perceive the combinations of colors in a more harmonious way.

We replace red with magenta. The latter color is too aggressive.

The complementation of blue with orange, rather than red, is preferable.

The value of violet has to be reduced to avoid the contrast between a light color and a dark color, instead of the contrast between complementaries.

Since the perception of color is psychological, we add to these notes three pairs of colors whose combination is discouraged because they tend to provoke viewer rejection. They are unwelcome combinations that produce negative psychological effects: purple and green, dark gray and yellow, and pink and black.

ANTICERNE *Effect*

SEASCAPE *Using the* ANTICERNE *Effect*

Some artists prefer to use a bright and saturated color as a base (orange, red, turquoise . . .) that is in sharp contrast with the subject matter, and to leave some areas unpainted deliberately to expose the color between brushstrokes. The effect, known as anticerne, produces great impact with appealing contrasts that give the compositions greater dynamic feeling. We will look at an example of the application of this method in a seascape painted with bright colors. A couple of photographs will be used as reference to create a horizontal painting. Exercise executed by Gabriel Martín.

1

After selecting a horizontal and panoramic format, we paint the entire background with bright orange. We sketch the model over the dried paint with a white pencil. We use a black pencil where the lines become more confusing.

Advice

The drawing does not need to be very precise. The façades are sketched with a few simple lines, disregarding any representation or perspective. Ingenuity and spontaneity should prevail over a naturalistic and detailed approach.

2

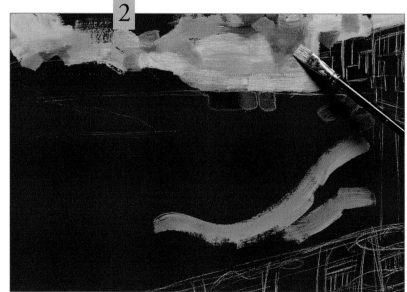

We paint the sky with variations of ultramarine blue, cobalt blue, and violet, all of them mixed with white. A flat brush is used to create a controlled area of color with good covering power.

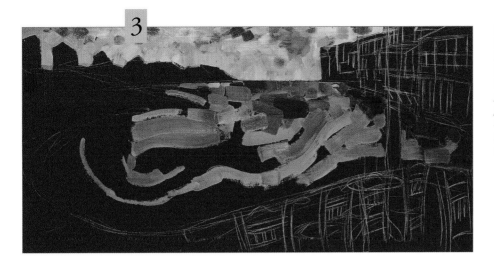

3

We cover the surface of the water with the same blues used to paint the sky. To these colors we add turquoise-green, which gives the water a feeling of proximity. The brushstrokes are long and wide and do not cover the background completely.

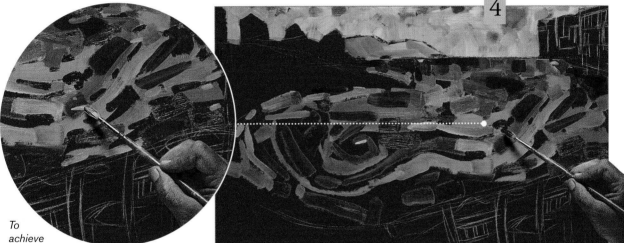

4

To achieve the anticerne effect, that is, a vibrant effect between colors, it is vital to leave small spaces through which the color of the background can be seen.

The brushstrokes over the water are not applied at random but following a predetermined plan, a spiral format that provides greater dynamic effect to the central area of the painting.

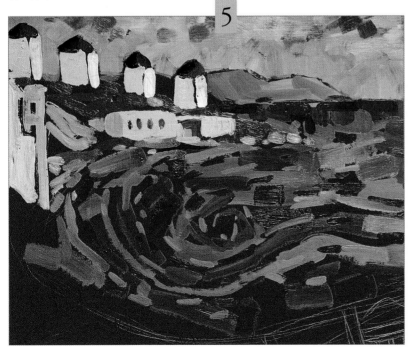

5

The group of houses on the left is treated with white painted evenly over each façade. These areas of color should not touch each other; a small space or edge is left in between through which the orange of the background can be seen.

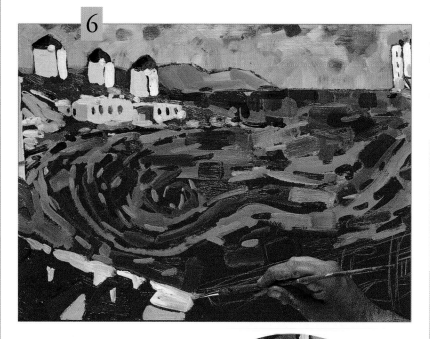

The tablecloths on the tables located in the terrace near the foreground are painted with red and green to create a very sharp contrast because these two colors are almost complementary to each other in the color wheel.

Advice

For the façades to be understandable, each brushstroke should be different from the ones next to it. The areas are shaded with a very light violet color.

Using white mixed with a small amount of yellow, we paint the wooden beam and the wall in the foreground. To represent the chairs, we simply outline them and then paint around them with blue so they look the same as the color of the background.

There are only a few details left; among them is painting the blades of the windmills with orange and purple brushstrokes. The composition shows a vigorous chromatic effect with brushstrokes that provide a feeling of agitation.

COLORS *and* ANTICERNE

The anticerne effect gives a very expressive character to the painting. This is due to the vibrant effect produced by the repetitive presence of loud and saturated background colors, which is felt throughout the surface of the painting. We will look at a few considerations for applying this interesting color effect successfully.

We must make full use of the contrasts between complementary colors. So, if the background is orange, blue should be the predominant color of the piece.

If the background has been painted with saturated red, green should outdo the other colors.

As in previous cases, if the background is purple, the presence of yellows will be necessary to achieve a complementary color contrast.

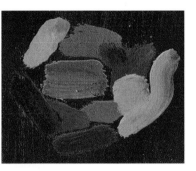

If we compare these colors, we will notice that the lighter blue brushstrokes produce greater contrast than the darker blue. Therefore, it is more productive to work with lighter colors.

With the anticerne effect, it is not necessary to combine areas of paint with lines drawn with a pencil or a thin brush. This is achieved by leaving a space unpainted; like an edge between each application of color, the contrast does the rest.

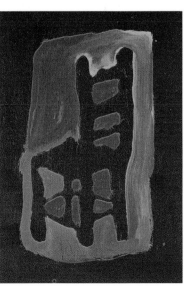

If we paint a large area with a color, to avoid covering the background excessively, small unpainted areas or spaces through which the color of the background can be seen can be left inside the area.

We can take advantage of the background contrast to represent the objects. In this case, the inside of the chair is not painted; instead it is constructed by painting the empty spaces that surround it.

SPATTERING *Effect*

URBAN LANDSCAPE *with* SPATTERING *Effect*

Let us experiment with the spattering technique. Remember that the idea is to spatter the paint onto the support to create textures or to make the areas that are painted with flat colors more interesting. This resource is a good complement to other techniques, and it is seldom used by itself in any painting. We begin the exercise by painting with opaque colors, to which we add a few texture effects by spattering. Exercise executed by Mercedes Gaspar.

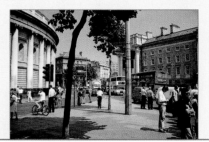

We mitigate the white of the support by covering the background with a very irregular grayish wash, where the marks of the brushstrokes are visible.

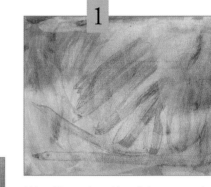

The space for the sky is painted directly over the background color with brushstrokes of whitened blue applied more or less opaquely. The asphalt is painted the same way with white broken with a bit of ochre on the tip. A stroke of yellow color is the first approach to represent the bus.

Advice

After the first application of colors, not before, we take advantage of the gray space to draw the main architectural lines of the buildings with a charcoal stick.

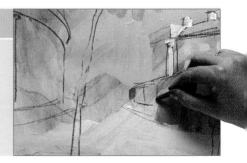

3

With very transparent ochre, we spatter for the first time over the sky and the asphalt. The only reason for this procedure is to break up the monotony of the colors.

The charcoal lines are a good guide for painting the façades of the buildings, with white or light ochre, that receive the effects of direct sunlight. With new brushstrokes of violet we add a few shadows on the asphalt.

The form of each element is achieved using contrasting colors. Each color is painted flat, mimicking the shape of the object represented, without visible modeling, shading effects, or details.

The foliage of the tree in the foreground is not painted with a conventional brush, but with a toothbrush loaded with thick paint. The paint is applied on the support by simply brushing sideways with the bristles.

4

The shadows of the asphalt are complemented with new gray shadows. The bus appears halfway finished with bright yellow and ochre. The architecture, despite the addition of new brushstrokes, has a sketchy appearance.

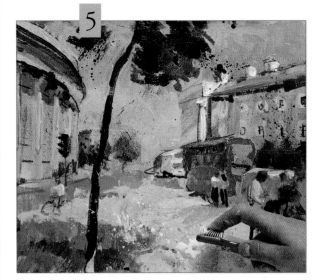

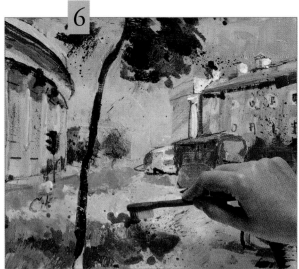

We apply the most decisive spattering effects when the painting is completed but still looking unfinished: green and violet for the tree leaves and white on the asphalt. We paint the tree trunk, which is seen against the light, with a thin round brush and a mixture of brown and carmine.

With a toothbrush loaded with a little thicker paint we apply new effects, this time with medium violet, on the shadow projected by the tree on the ground. This provides greater variety and richness to the range of grays and violets used in this area.

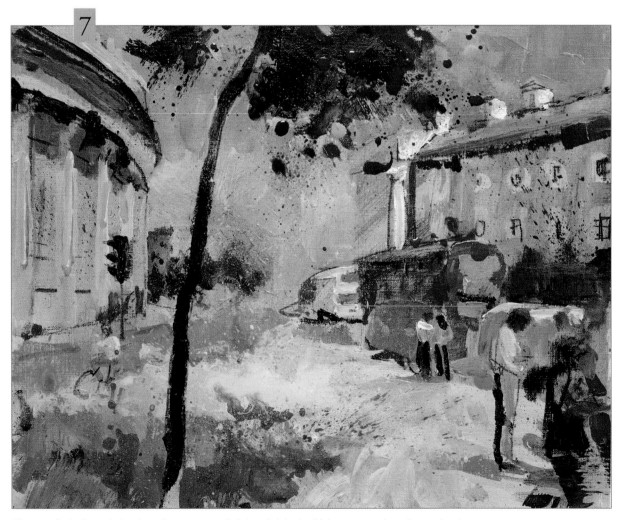

The people in the painting have been purposely left unfinished with just two or three layered colors. The most distant buildings are also represented with a shapeless mass of color, while the building on the left has richer colors and greater detail.

SPATTERING *on the* SUPPORT

Today, many artists who pursue textured, expressive, casual, atmospheric, or visceral effects in their work use diluted acrylic paint. Since craftsmanship is no longer the only measure of the quality of a painting, other techniques, such as spattering and even splashing paint on the support, have become very popular among artists as a way to express the impact of the painting on the support or a gestural act.

If we rub a toothbrush loaded with paint, we will make the paint come out in droplets that will cover the entire surface with dots.

By spattering we can combine several layers of different colors (in this case, red and violet), as long as the previous layer of paint has dried completely.

If we spatter too much or if we add several layers of paint without waiting for the lower ones to dry, we will create puddles of paint. The droplets end up fusing with each other, and the colors mix without any control.

If we wish to mix several colors to create a spontaneous look, it is better to work with a thick brush and to splash larger drops.

Not only is a toothbrush useful for spattering, but it can also be used to create interesting linear textures when it is rubbed against the support.

If we make a reserve with a piece of paper in one area of the support and spatter paint, and then repeatedly move the paper and spatter again, the result will be a tonal scale.

We can make different cut outs on a piece of construction paper. When we place them on the support they protect the covered part from the spattering, which results in an unpainted area in the shape of the cut out.

After analyzing the different ways of spattering paint, we can experiment with small compositions to practice the effects.

53

TEXTURED *Base*

WORKING *on a* TEXTURED *Base*

Acrylic paint is the best medium for working with impastos. In this exercise, we are first going to apply texture to the base with several layers of material. The paste is very thick and incorporates a charge (pumice, marble dust, plaster, very fine sand . . .) to give some texture to the finish. When the layer of impasto is dry we paint over it with acrylics. Exercise executed by Esther Olivé de Puig.

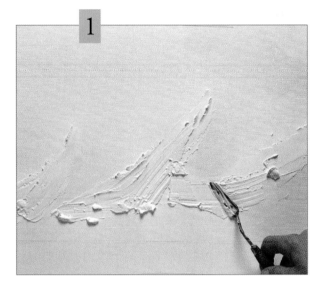

The first impasto is done with white modeling paste, which is special for working with acrylics. We spread a generous amount with the spatula on the middle section of the painting. The texture is supposed to represent the boats.

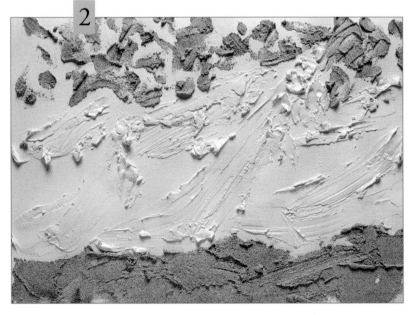

Advice

Many painters believe that impastos are more effective if they reflect the personal style of the artist for working the paste, and that it is a mistake to apply the paste inconsistently.

With the gray pumice paste, we cover the area of the water working it with a flat spatula. The top part of the paper is worked with small dots that are applied by pressing the paint with the tip of the spatula.

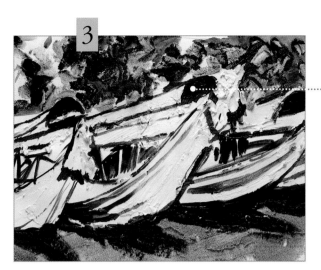

The paint must have a dense and thick consistency, but it must be fluid; otherwise, it will be very difficult to paint with long and continuous strokes on a coarse and textured surface.

Once the textured surface has dried completely, we make a monochromatic drawing with a medium round brush. First, we sketch the outlines of the boats, and then we shade the background.

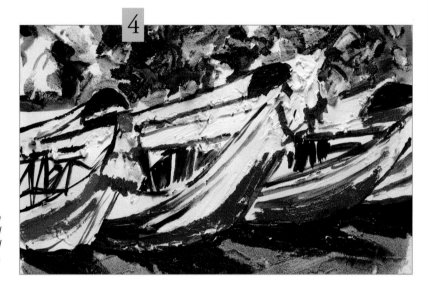

We begin painting the boats with strokes of layered colors. The textured surface makes them appear elongated and very irregular.

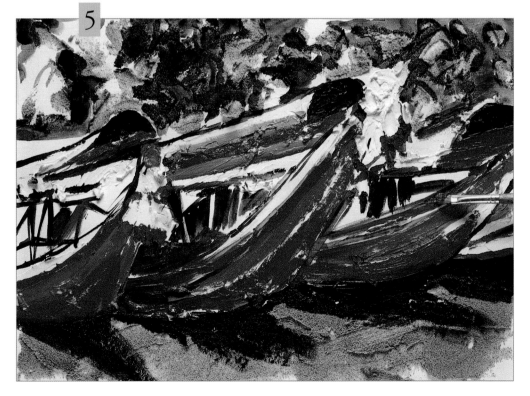

Each brushstroke presents a color that is clearly different from adjacent ones. It is a good idea to prepare a generous amount of paint because the brush loses its charge quickly after it touches the support.

6

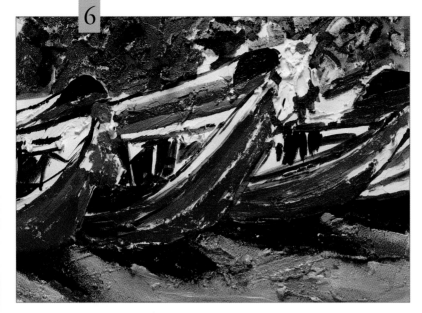

Advice

With this type of paint, the brushes wear out quickly; that is why we recommend using synthetic brushes or bristle brushes.

Even though the white texture does not alter the color when painting the water and the leaves on the trees, we will notice that we have to work with thicker paint to prevent the gray texture from coming through and muddying the colors.

The hanging decorations are painted with a thin round brush loaded with thick paint. Imagine a series of abstract strokes of color. The paint must be thick and have heavy impasto.

7

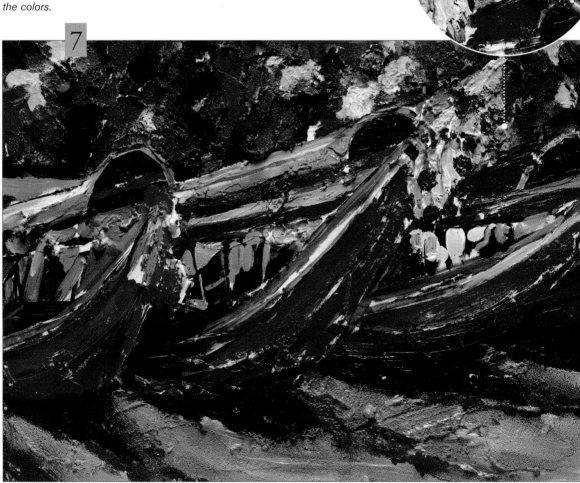

The leaves on the trees are constructed with layered brushstrokes of different green tones. The water is painted with flat areas of color that present clear tonal gradations ranging from black to ochre. Details or minute accents are not painted; the ragged texture prevents it.

EFFECTS *with* TEXTURE

After this interesting exercise, we are going to study individually the possibilities offered by the preparation of the bases with acrylic painting. The effects that are described below have been executed with acrylic paint mixed with *gesso*, all of them with a metal spatula except for one, which has been done with a bristle brush.

Each impasto has its color. If they are juxtaposed, the colors overlap without becoming mixed.

Over a painted background, we spread a broken impasto that does not cover the surface completely.

If we mix the colors directly on the support rather than on the palette, the impasto will look fragmented.

When we apply the impasto colors with a brush, the thickness of the layer of paint is not as great, but the direction of the brushstroke is visible, which creates more shading effects.

If we apply an impasto with a solid color and we let it dry, then we can paint over it with a brush. If the paint is thick, it goes into the folds and wrinkles.

If on the other hand we apply the impastos with a wash, they end up seeping into the folds, forming puddles, and making the outstanding areas lighter in color.

We can form textures on a wet impasto changing its surface. The best way to work in this case is with the rounded tip of a spatula.

Similarly, by pressing with the tip, we can produce sgrafitto effects that expose the underlying color.

57

COLLAGE *and* ABSTRACTION

Modern Techniques:
COLLAGE *and* ABSTRACTION

Let us attempt a more creative exercise. We will interpret the model by gluing color papers and newspaper clippings and by painting over them with bright colors to create an abstract composition. The consistency and fast drying time of acrylic paints has made them one of the most commonly used mediums by artists who pursue abstraction. Exercise executed by Gabriel Martín.

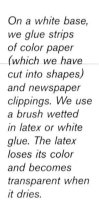

1

On a white base, we glue strips of color paper (which we have cut into shapes) and newspaper clippings. We use a brush wetted in latex or white glue. The latex loses its color and becomes transparent when it dries.

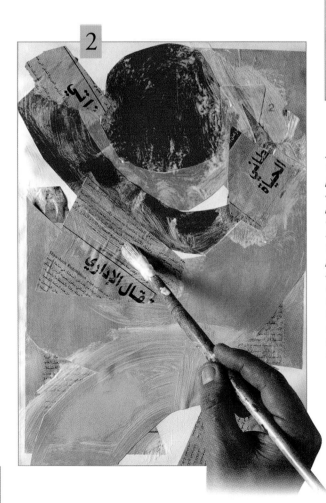

2

At the same time, we take another piece of paper and we repeat the previous operation changing the shapes and the colors of the papers and arranging them differently. After comparing the two collages, we select the second one for our exercise.

Advice

Latex can be mixed with acrylic paint. It makes the paint more fluid and somewhat more transparent, and the paint is glossier when it dries.

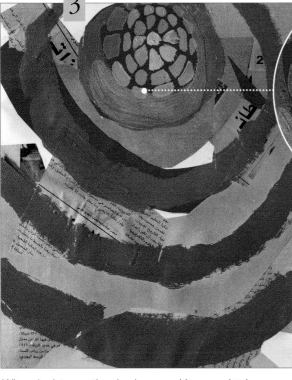

3

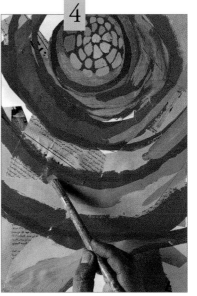

We use a small brush to paint the stained glass of the cupola over the orange paper. We combine ultramarine blue and green with a small amount of white, forming a clear gradation effect.

When the latex on the glued papers dries completely, we proceed with the acrylics. We paint the stained glass of the cupola. We form concentric circles around it with a generous amount of yellow. The goal is not to copy the model but to interpret it.

4

We paint the red and orange circle around the cupola, adding values to the previous shapes with shading by combining two different tones of green. All the brushstrokes are applied in a spiral configuration following the original model.

5

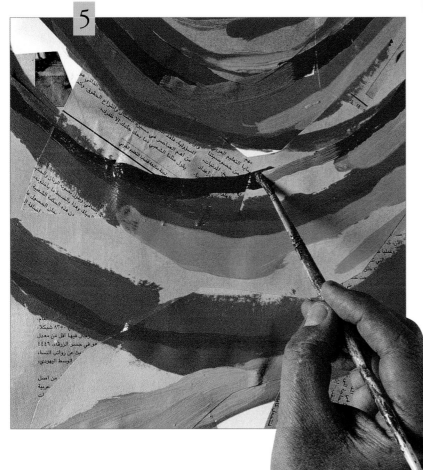

Up to this point, we have worked with yellows and greens; now we create greater contrast by highlighting the concentric circles of the architecture with red. The strokes are not applied evenly; they show orange, salmon, and red variations.

The addition of the red lines is vital to capture the linear concept of the original architecture. Besides, they contrast sharply with the green areas because these colors are complementary.

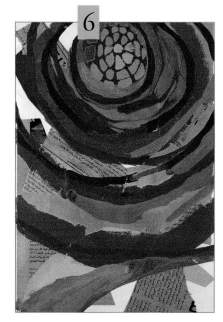

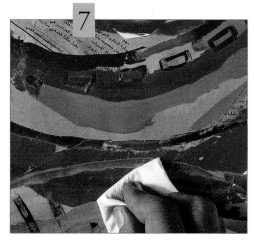

The last elements to be incorporated are a few blue lines. To achieve graphic variation, the paint is not allowed to dry completely. We press a piece of bloating paper against the line to create an unfinished effect.

The greatest appeal of this work resides in the chromatic variety provided by the contrast between the brushstrokes of color and the flatness of the color papers. The spiral configuration generates an interesting kinetic effect.

We should avoid covering completely the collage of color papers that are still visible between the brushstrokes. The last addition consists of a few graphic elements painted in blue.

VARIATIONS *of a* THEME

When we approach a model, it can be very helpful not to limit ourselves to one representation. It is a good idea to work with several colors to introduce different variations and interpretations that offer us the possibility to analyze and experiment with the composition and the color. This approach will help us overcome the technical difficulties, to develop creativity, and to understand that one model can offer different options for working it.

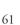

1. We take the other collage, the one that we had discarded at the beginning of the exercise. The design is similar to the previous one, although it presents a few variations of form and color.

2. It is necessary to change the placement of the areas of color and to introduce different graphic effects. In this case, the stained glass pieces of the cupola are larger. We introduce a few sgrafitto effects with the handle of the brush while the paint is still wet.

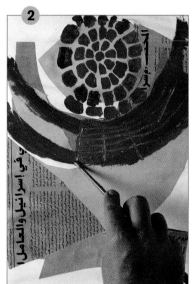

3. The painting evolves, taking a different direction than that of the exercise. With a thin round brush and a range of green, blue, and turquoise colors we repeat the shapes of the stained glass pieces placing them in circles over the entire surface of the painting.

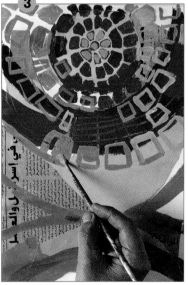

4. The painting followed the photograph as a starting point, but it has departed from the real model, much more than in the previous case. It is important not to be afraid of being creative and subjective to achieve personal representations.

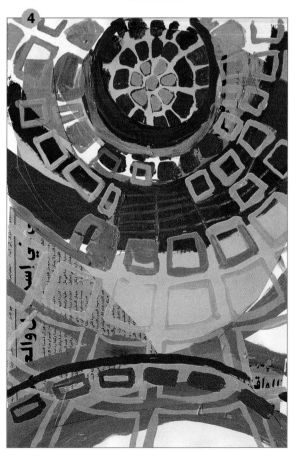

EXPRESSIVE

EXPRESSIVE *Approach to the Human* FIGURE

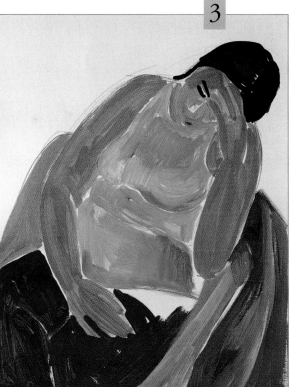

We end the book with a very simple exercise. The idea is to paint a human figure with a very colorist and expressive approach. We avoid any academic representation that could create problems with the drawing. Our goal is to produce a piece with synthesis and color, without attempting any anatomic correctness and avoiding any resemblance with the model. Exercise executed by Esther Olivé de Puig.

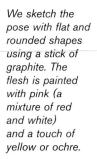

We sketch the pose with flat and rounded shapes using a stick of graphite. The flesh is painted with pink (a mixture of red and white) and a touch of yellow or ochre.

We begin by painting the pants very spontaneously with pure naphtol red, in other words dispensed directly from the tube. To add nuances to the color, we mixed the red slightly with brown sienna. This combination is visible in the area of the left thigh.

The way to proceed is simple; the idea is to work by areas. Now we apply paint to the blouse, which we solve with variations of violet, and the blanket that covers the sofa, with a combination of dark brown and ochre.

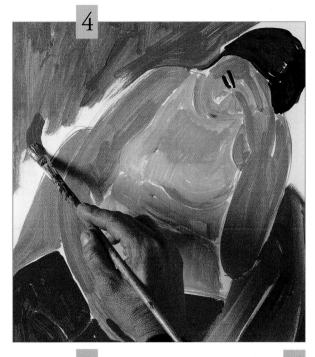

4

The last area left to paint is the background. Since the figure dominates the red and violet tones, we paint the background with light ultramarine blue. We apply the paint broadly and spontaneously, leaving the brushstroke marks visible.

We mitigate the impact of the black contours with the final applications of color. They should not be covered completely; instead they should be visible at different degrees.

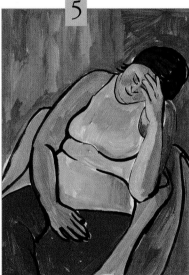

5

With a medium round brush we go over the outlines of the figure with a black line of uneven intensity. Using the same color but this time with a thin round brush, we sketch the facial features with simple lines.

We add new values and nuances over the previously painted surface by layering areas of color over the arms, which have some light reflections. The texture of the blouse is recreated with short and juxtaposed brushstrokes, and the blanket's pattern is painted with sienna brown.

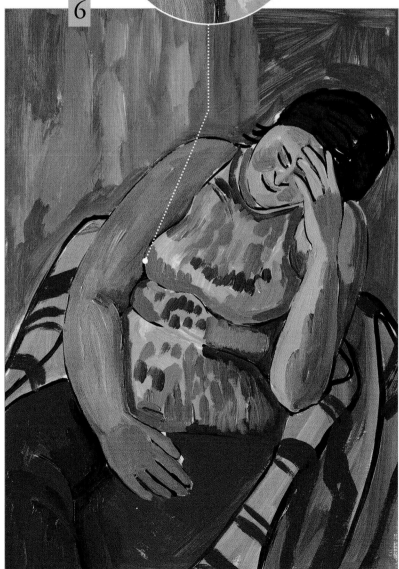

6

JEAN DUBUFFET
(1901–1985)

Photograph of Jean Dubuffet.

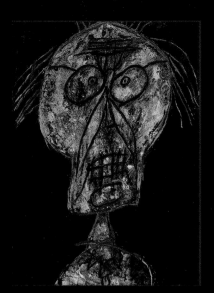

Jean Dubuffet, André Dhôtel Shaded with Apricot, 1947. Oil on canvas. Centre Georges Pompidou (Paris, France).

Although he began his formative years as a painter in 1910, Dubuffet did not devote himself completely to painting until after he turned forty. At the end of the 1950s, Dubuffet began to use other techniques of greater graphic tendency, drawing his inspiration from advertisements and from decorative works. The technical changes of his art were determined by the appearance of new materials such as plastic and vinyl paints and polyester resins. He talked about his interest in experimenting with the new paint in some of his writings: "My relationship with the material that I use is like that of a dancer with his partner, of the rider with his horse, of a clairvoyant with her tarot. It is possible then to understand the interest that I feel for an improved material and my eagerness to try it." After studying for a couple of years the possibilities offered by the new medium, beginning in 1962, his style and the theme of his paintings changed because "art has to be born from the material. Each material has its own language, it is a language."

His work is full of forms that spring from the crossing of random lines with a few elementary colors. This way, Dubuffet begins his longest and most important series, which he calls "L'Hourloupe." In it, the author plays with doodles and lines. He limits his palette to red, white, black, and blue, in his attempt to evade esthetic praise. "I have the need to use very simple color mixtures (and, therefore easy to repeat identically), even colors, like the ones that come in commercial boxes and without any mixtures. . . . It matters very little to use black or blue or red to paint a face or a tree, while it does much more to give a

specific use to the chosen color. My painting could very well be painted only with black, but diversified and applied in one thousand proper ways. Colors have less importance than it is commonly believed. But the way it is applied has more."

The pictorial language of Dubuffet turned gradually more similar to a decorative puzzle. He wanted to seduce, to celebrate deformity and the materials that appear grotesque at first glance. "Instead of the mechanical deformities of classical linear perspective, I prefer deformities derived from expressive intentions in which the ingenuity, the inventiveness and the whimsical play the proper way."

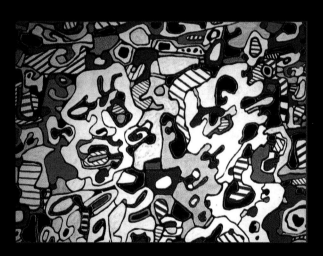

Jean Dubuffet, Amorous Propositions, 1967. Vinyl paint on canvas. Private collection.

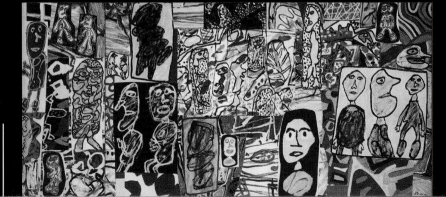

Jean Dubuffet, The Social Court (fragment), 1977. Acrylic on paper and canvas. Private collection.